JASPER
JOHNS

First published in the United States of America in 1997
by UNIVERSE PUBLISHING
A Division of Rizzoli International Publications, Inc.
300 Park Avenue South
New York, NY 10010

and THE VENDOME PRESS

Front cover photograph: © ADAGP, 1997
Back cover photograph: © Hans Namuth, 1986

Text and captions translated by Lillian Clementi

ISBN 0-7893-0085-0

Printed and bound in Italy

Library of Congress Catalog Card Number: 97-060140

JASPER JOHNS

FOREWORD BY LEO CASTELLI

UNIVERSE / VENDOME

the year was 1957. I had begun to take an interest in American painters several years previously, and I had a high opinion of the Abstract Expressionists, such as Pollock and de Kooning. Since the American art world had given prominence to the European artists whom the war had forced to emigrate to the United States, I thought it only fair to showcase these young painters, whose works were suffering from a genuine lack of recognition.

A first show at the Sidney Janis Gallery was followed by the Ninth Street show in 1951, which brought these unrecognized painters to the attention of specialists like Alfred Barr, Director of New York's Museum of Modern Art. Among the youngest artists I had chosen for this very haphazard show was Robert Rauschenberg, who seemed to me to be breaking away from mainstream art in the United States. His bold approach to collage, for example, and his way of incorporat-

ing elements that his predecessors had not used, made him very different in my view. A number of reasons can be cited for his methods, including the influence of Duchamp, or even Rauschenberg's extreme poverty at the time, which led him to choose odd objects from the street and use them in his paintings. Nevertheless, he made a considerable impression, and I reacted to his works with a great deal of emotion.

He still had not found acceptance in the United States; paradoxically, his first success had come in Europe, and especially in France. I wanted to show him in the U.S., and I set out to do that in 1957, as soon as I had made the decision to set up my own gallery. It was on this occasion that I met Jasper Johns.

I knew very little about him of course, because his background and early years as an artist were an enduring mystery. Nonetheless, in a show at the Jewish Museum I had seen a very strange painting by him: a green composition embellished with a curious circular, concentric design. Even the material seemed unusual: it was not until later, when I knew his work better, that I learned it was encaustic—an ancient method abandoned for centuries.

And so it was in talking to Rauschenberg about the exhibition I was planning, and the painters I could show with him, that we came to talk about Jasper Johns. Rauschenberg knew him very well, since their studios were virtually next door to one another, and we immediately went to see his fellow artist. There in his studio, surrounded by a profusion of improbable subjects for paintings—American flags, targets, series of numbers and letters—I had a distinct intuition of his extraordinary importance. That same day, without taking time to think about it, I asked Johns to join my gallery, and he accepted immediately.

As a very young man, he had been profoundly influenced both by his friendship with Rauschenberg and the music of John Cage; he was then twenty-seven years old. For reasons known only to himself, Johns had destroyed almost all of his canvases several years earlier, and since then had devoted himself tirelessly to exploring a handful of themes—the American flag for example—which have generated numerous commentaries by art critics and by Johns himself.

I n 1957 it took tremendous creativity for an artist to display such willingness to break with the prevailing Abstract Expressionism and to center his work around objects as common and humdrum as an American flag, which strays from its normal meaning in Johns' hands. The flag's format tolerates no originality; Johns' scrupulous adherence to the number of stars, first forty-eight and later fifty, is undeniable proof of that. But in the flag Johns found a framework rigorous enough to achieve his objective of covering a surface with color in such a way as to allow an infinite number of variations, even if they are inaccessible at first to the neophyte.

Much has been written about the way Johns depicted the flag as a flat surface, not supple or undulating, as in the work of his representational predecessors. Here is proof, if any were needed, that the flag is only a pretext for the work of art and not, strictly speaking, its subject. How else can we explain the various flags he has painted—juxtaposed on the same canvas, superimposed concentrically, or in monochrome versions in all of which the artist seems to be mocking himself?

In fact—and I didn't understand this until much later—the fascination Johns' paintings exerts on the enthusiast lies chiefly in the way they are painted. His technique is highly sophisticated: first he covers the canvas with newspaper, which alternates dark columns of text with light margins to suggest a movement that remains perceptible even after the artist has covered it with the main material—which is extremely thick, as it is made of encaustic mixed with still hot pigments. Its application permits numerous variations depending on the implement used by the painter and the direction he gives it. The extraordinary richness and originality of this process, which can already be felt in Johns' earliest works, lays the groundwork for a completely new experience whose astonishing character made our unexpected encounter the turning point in both our careers.

Apart from the flags, Johns had also produced a number of paintings of signs and everyday objects; targets in various colors, sometimes topped by small plaster casts that could be hidden or displayed at will by a shutter mechanism; and series of numbers and letters treated in such a way as to obliterate them to the point that only the subtle variations of color could be seen on the canvas. Like the flags, these motifs had no other purpose than to provide the painter with a space for meditation, a surface on which he could give free rein to his desire to paint and to the inspiration that transfigured symbols of everyday life.

While Johns' work was atypical at the time, he had no intention to scandalize, and often explained that his work was not a revolt against Abstract Expressionism, as believed by a number of critics. I personally think it should be put down entirely to happenstance.

I was astonished that so creative an artist had not yet found a dealer to introduce him to the public, that he was, so to speak, "available." But it is important to remember that there were very few galleries at the time, that each of them had established its "niche," and that they paid little attention to artists as unconventional as Johns. Although Betty Parsons, who ran an avant-garde gallery, had also made overtures to him through Rauschenberg, their meeting had been postponed. Thanks to my colleague's misfortune, I was the first to show Jasper Johns' paintings.

I made the decision as if I had fallen in love at first sight, and afterwards, I seem to remember that things happened very fast. On occasion, the outside world steps in to support a gamble prompted by a sudden, bold impulse, as seen, for example, in the reaction of my friend Tom Hess, the powerful director of *ARTnews* magazine. He stopped by my gallery shortly before we hung the show, during the last few days of 1957, with the paintings still on the floor. He caught sight of one of the targets I mentioned earlier, which Jasper had topped with four compartments revealing the lower parts of faces—chins, mouths and noses—with those little shutters that could make them disappear. Tom was determined to take the work with him on the spot, and I couldn't help being surprised, even anxious, since he fully intended to get into a taxi with the painting as is.

But it was all for the best. I knew I had been right to go ahead when I found a reproduction of the painting on the cover of *ARTnews* in January 1958. Johns' was a tremendous and sensational arrival. I personally see it as proof that American art was at a turning point and that Abstract Expressionism was beginning to make room for other artists, largely because it had found almost no successors in the younger generation. My stroke of luck, combined

with Johns' unquestionable talent, is undoubtedly the explanation for the immediate success of my 1958 show.

After the honors in *Art News*, we expected that the show would draw enormous crowds, which it did as soon as it opened to the public. To my delight, Alfred Barr himself rushed in and wanted to buy a painting right away for the Museum of Modern Art. This led to an interesting series of events: he had originally decided on a large target with compartments showing various body parts, including a green plaster penis that he would have preferred to hide from the members of the Museum's Acquisitions Committee. Since Jasper was not inclined to agree, he finally settled for the target that had already bewitched Tom Hess, plus an American flag that he went to a great deal of trouble to buy indirectly through one of his personal friends, again because of the Acquisitions Committee's predictable reaction to what might be considered insolence.

These two paintings, along with the green target that had first impressed me at the Jewish Museum, gave Jasper Johns a place in the Museum of Modern Art. At the same time, he was making a name for himself in the broader world of contemporary American art. All of the paintings in the show sold within a few days, except for the famous target with the green penis, which I kept until recently (It is now in David Geffen's collection in Los Angeles).

Jasper Johns became one of my gallery's benchmark artists, a status he never lost in the thirty-five years that followed. During this time, I followed the evolution of his work with the closest attention, and I began to delineate a number of distinct phases.

When I met Jasper, he was just moving toward producing three-dimensional works—by that I mean objects more elaborate than the little plaster casts he had added to some of his paintings. In sculpture he preserved the same principles he had applied to his paintings: in one, for example, he flawlessly reproduced the exact configuration of the American flag. I flatter myself with being the indirect source of the now-famous bronze cans of Ballantine beer. When Willem de Kooning joked that I could sell anything, even beer cans, Jasper set out to prove him right, and that is exactly what I ended up doing with his surprising bronze. To make it even closer to the original, he reproduced the Ballantine label with perfect accuracy, thereby elevating the "real" beer cans to a work of art. Once again, Johns was taking his inspiration from the trivia of everyday life, but with a hidden agenda that gave symbolic value to these ordinary objects.

This same line of reasoning underlies the subsequent series of Johns' sculptures—from flashlights to lightbulbs—that began to emerge around 1960. These works can be attributed in part to the influence of Duchamp, whom Jasper met around this time.

1960 also marked the beginning of a period in which Jasper Johns integrated whole words into his paintings—names of colors, for example, which transcribed a new type of "reality." In some cases these words even lent the painting its title, which was placidly incorporated into the surface of the work itself. I can't help feeling a surge of lightheartedness today when I contemplate canvases like *False Start* or *Device*, so violently charged with the primary colors, yellow, red and blue. This is not merely a return to abstract painting, but an entirely new painterly technique, as seen in his 1961 map of the United States. While the map is faithful to

the original and accurately bears the name of each state, it is filled with movement expressed by color, conveying the artist's claim to a new freedom.

Little by little, even as he continued to work relentlessly along his original paths, Jasper Johns would expand the scope of his compositions. From this point on, he offered works on a completely different scale from that of their predecessors. This expansion extended to technique as well, as he would incorporate into these works ever more eclectic objects. This new eclecticism first appears in the famous *Painting with Two Balls*, and it continues to assert itself after 1962 in paintings like *Diver* and, of course, *According to What?*

In the sixties we see his favorite themes endure, with the targets, the American flag, and the map of the United States endlessly taking on new forms. From this point on, however, the artist places within our reach new, enigmatic elements that he includes as he sees fit: fragments of the human body; such traditional painter's tools as brushes; the famous Savarin coffee can; or pieces of furniture. I believe that these elements reflect a sense of theatricality, reminding us that Jasper designed scenery and even entire productions for Merce Cunningham's ballets (often performed to the music of his friend John Cage).

I must also mention the series of paintings that began in 1967 with *Harlem Light*, which he said was prompted by a fleeting glimpse of a wall made from irregularly shaped stones. According to Jasper, he wanted to photograph the wall, but was in a car on the way to the airport and didn't have a camera with him, so he had to settle for reproducing it from memory later. The "flagstone" configuration that this flash of inspiration suggested was one that Jasper Johns

would reproduce again and again until the end of the sixties, in an immutable motif of black, red and white.

But the most extraordinary of Jasper Johns' techniques, to my mind, are the powerful colored stripes he calls "crosshatchings" parallel lines that break and conflict with one another before our eyes. Easily dismissed as insignificant, they carry a message that we must decipher, sometimes with the help of the title, sometimes without. For the universe of Jasper Johns is rich with references from his vast cultural knowledge. It is a universe where the work of painters as diverse as Grünewald, Edvard Munch and Picasso crosses paths with that of such literary figures as Céline and Tennyson, to name only a few. As the sixties gave way to the seventies, then, Johns began to establish a new expressive language by using simple shapes bearing the crosshatched pattern, which, I am convinced, is nothing more than a variation of his original invention.

It was around this time that Jasper came across Edvard Munch's *Self-Portrait Between the Clock and the Bed*, in which the Norwegian artist had used a two-tone crosshatch treatment to depict the bedspread. Thirty years later, Johns' three paintings titled *Between the Clock and the Bed*, would refer explicitly to Munch's work while at the same time completely deconstructing it according to the system developed in Johns' earlier paintings, creating an entirely different composition based on an identified model. The comparative transparency of these three major works gives us insight into the inner workings of the process, which would appear to stunning effect in laters phases of Johns' work.

While Jasper continued to develop a variety of painterly techniques, pursuing all of them at the same time, his earlier works met with growing success. While his first targets

sold for just under one-thousand dollars in 1958, his *Double White Map* was auctioned for $240,000 in 1973, and in 1980, Johns passed the million dollar mark when the Whitney Museum of American Art acquired *Three Flags*.

Of course, once works are in the hands of the public, their prices are uncontrollable. Demand at the gallery was so great that I never had enough paintings on hand, and in the end had to put potential buyers on a waiting list. If, in addition to the enormous popularity of his paintings, we consider the very high value that his prints have always enjoyed— and Jasper can pride himself on a sizable body of prints that are no less varied than his paintings—the result is mind-boggling.

During the eighties we saw Jasper introduce entirely new elements, as well as representational techniques that signaled a digression from past motifs. The paintings, containing small objects affixed to a highly decorated background, now incorporated art history icons that were important to Johns (the Mona Lisa that we find taped to the center of *Racing Thoughts*, for example, can scarcely be anything but a suggestion of Duchamp). Real or metaphorical objects were now shown in perspective or simply outlined.

n ow I was beginning to see in Johns the surge of a new artistic inspiration—one that reached its maturity in *The Seasons*. The self-implicating silhouette that haunts each of the four paintings in this series has been the subject of extensive analysis. This personal appearance by the artist in his work marks a decisive turning point in Johns' career. Up to this point the artist had sought to keep personal feelings out of his paintings; now he had suddenly

resolved to "drop his defenses," as he put it. Gathered around him in *The Seasons*—in an order that varies from season to season but never loses its creative tension—are symbolic elements from his earlier work, or influences that have always guided him: Picasso, Grünewald, and the Mona Lisa reappear either in a simple representational treatment or crosshatched.

I first showed *The Seasons* at the gallery in 1987, and in 1988 they won the Grand Prize at the Venice Biennale. This formidable series is not simply a backward glance, nor is it simple reflection on the passage of time. It represents the hope of rebirth. In the quest that Jasper Johns pursues on his own terms, moving closer to the absolute with each painting, he is deepening the resolve that I have admired ever since our first meeting. Today, one might say, he is the American painter *par excellence*. But above all he is a tireless artist whose integrity and prodigious output have naturally placed him in the forefront of twentieth-century art history.

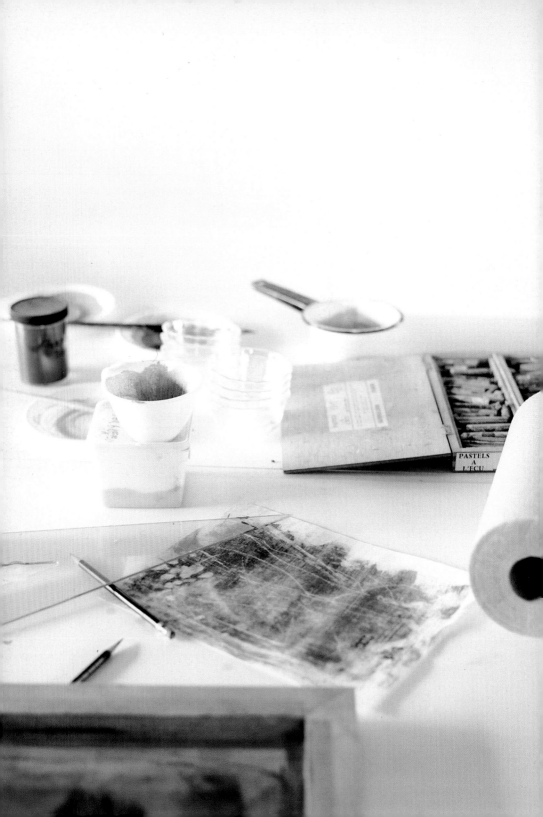

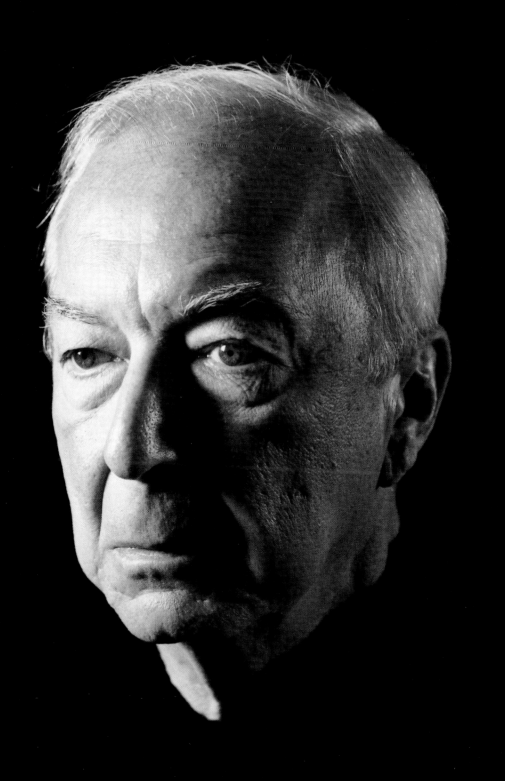

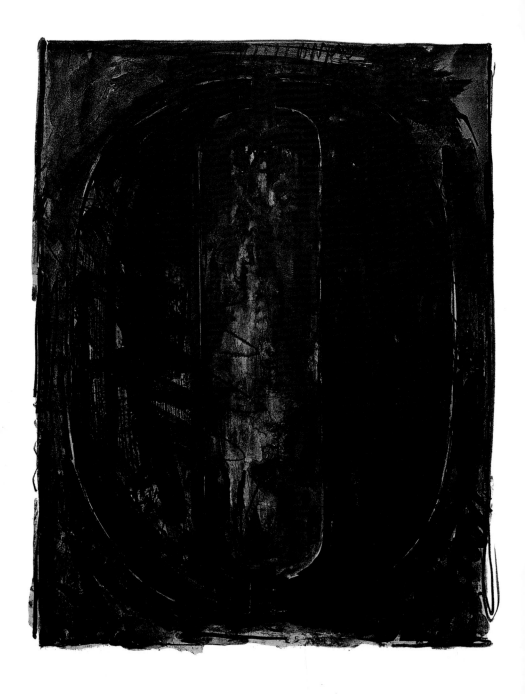

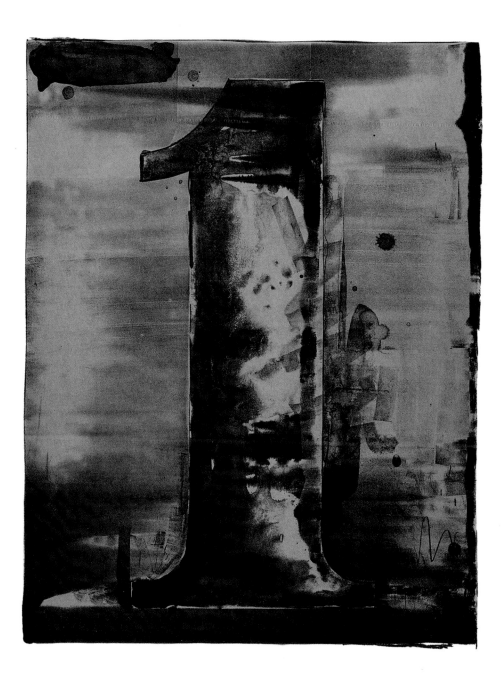

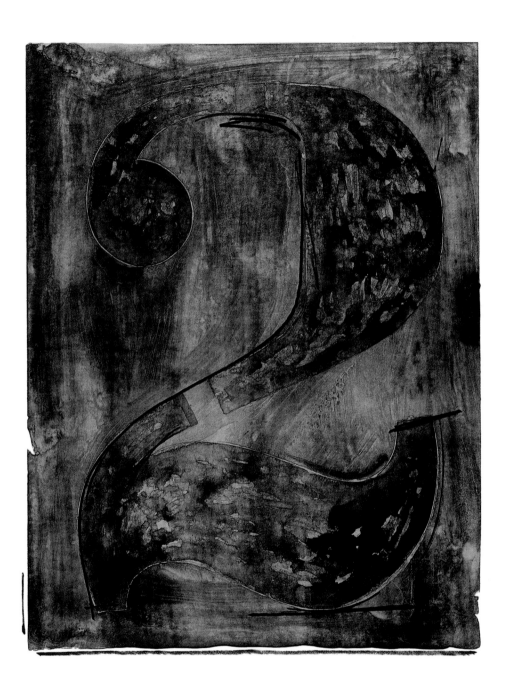

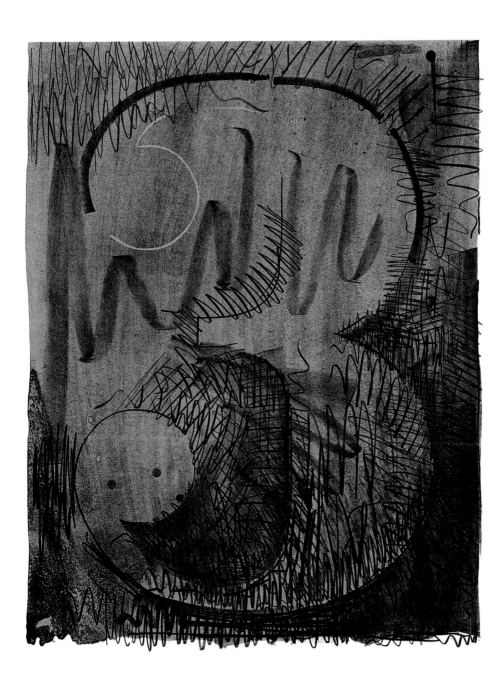

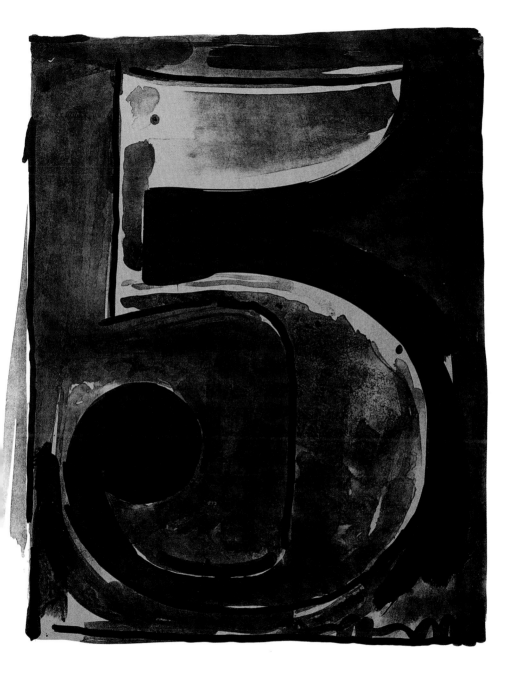

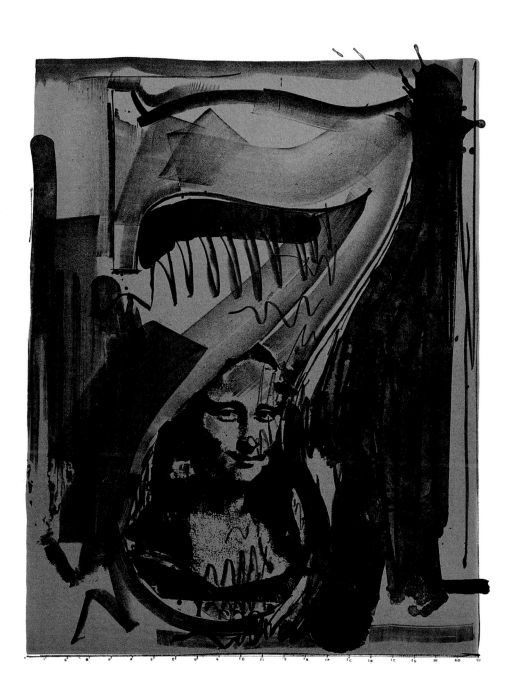

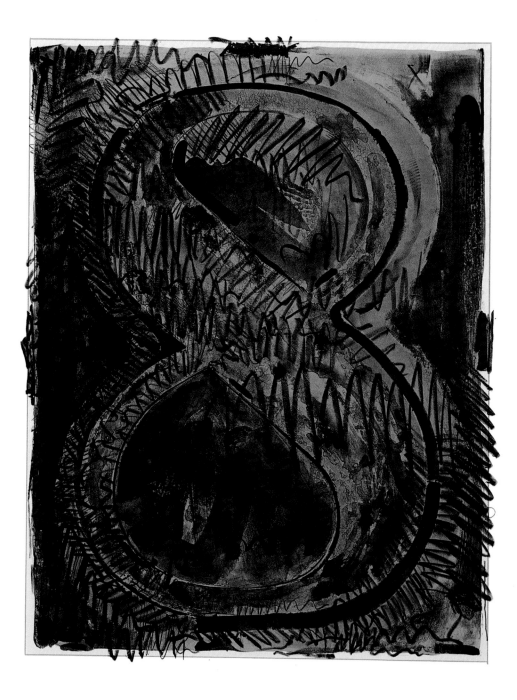

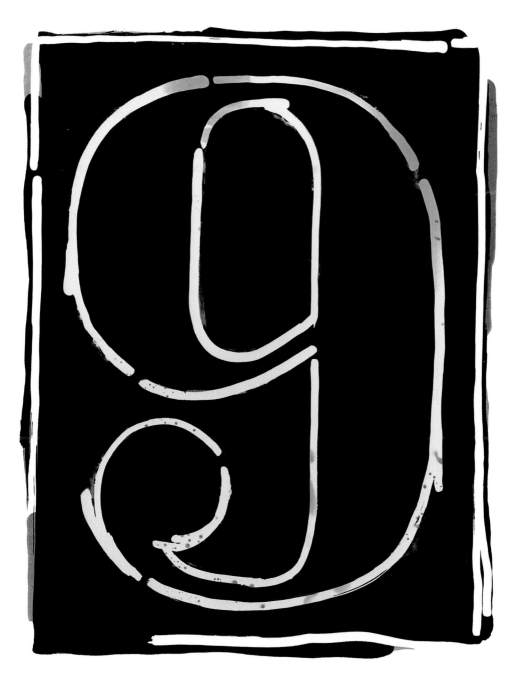

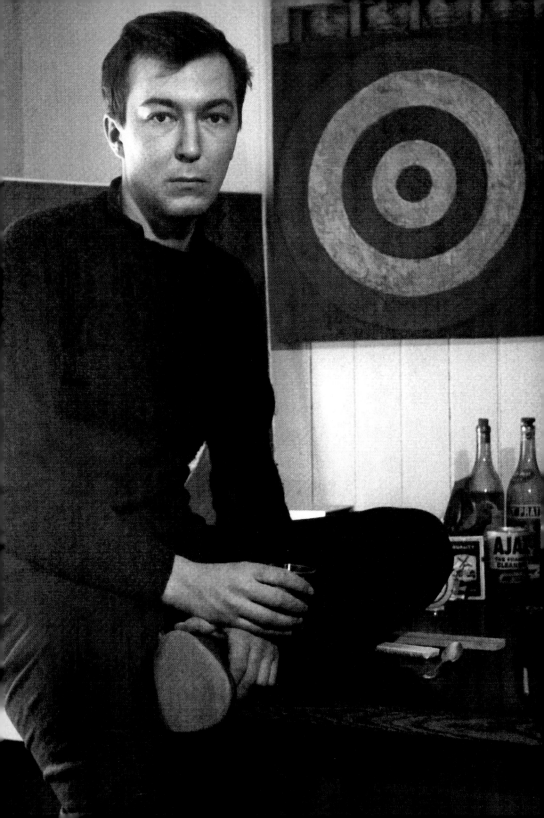

ART NEWS

FOUNDED 1902

January 1958
One dollar

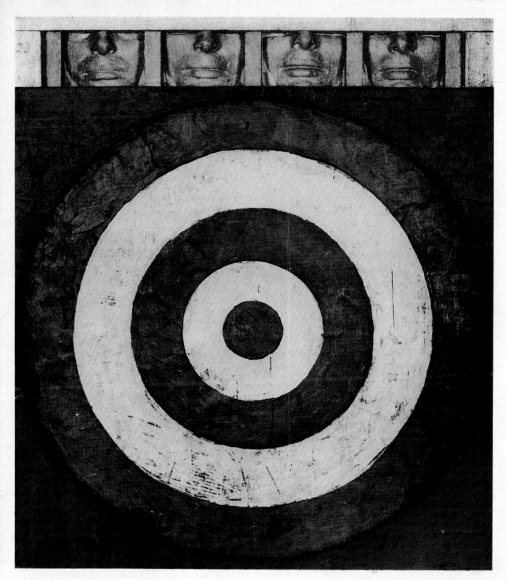

New poems about paintings | The year's best in art | Treasure from Korea

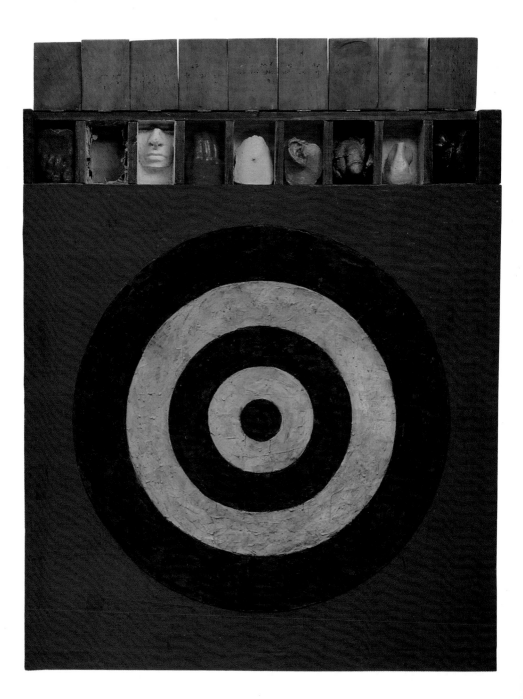

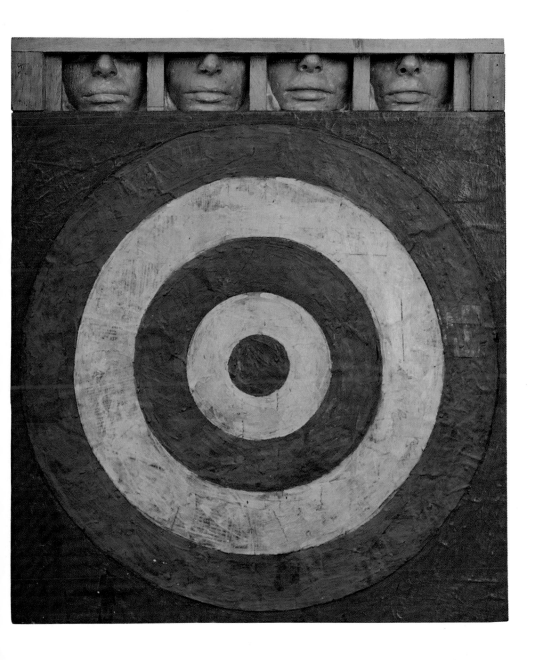

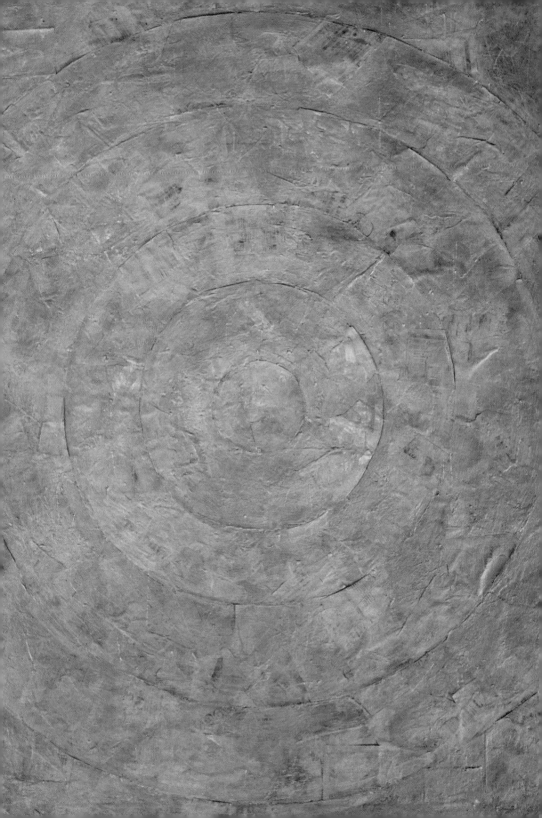

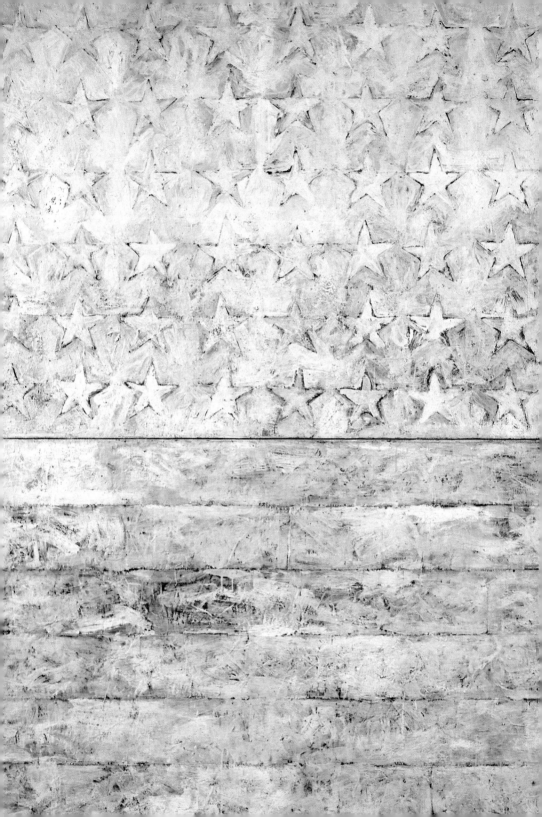

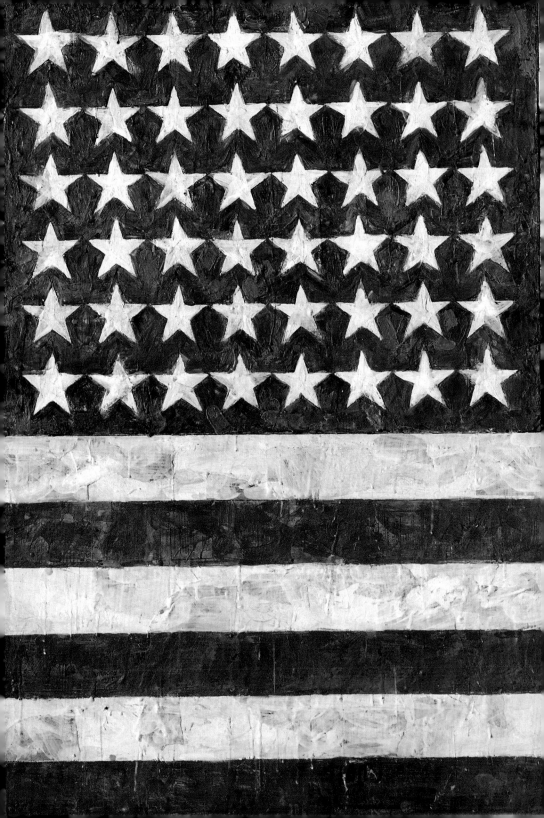

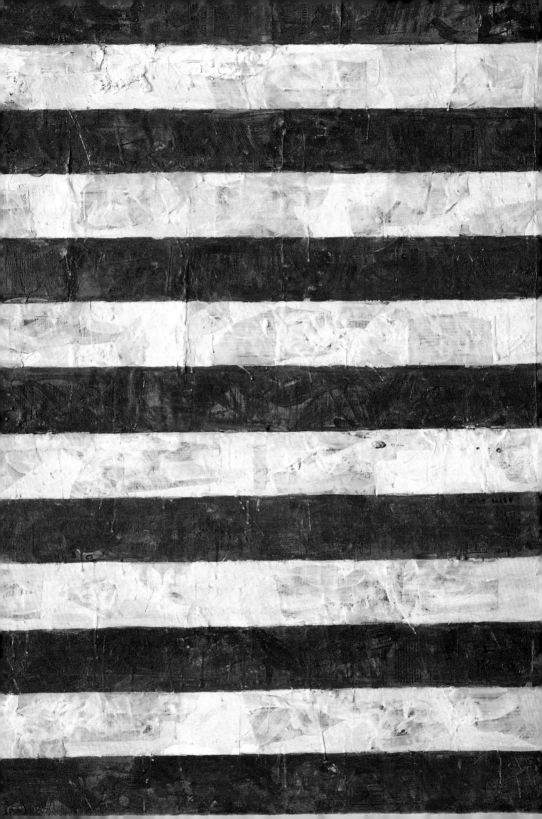

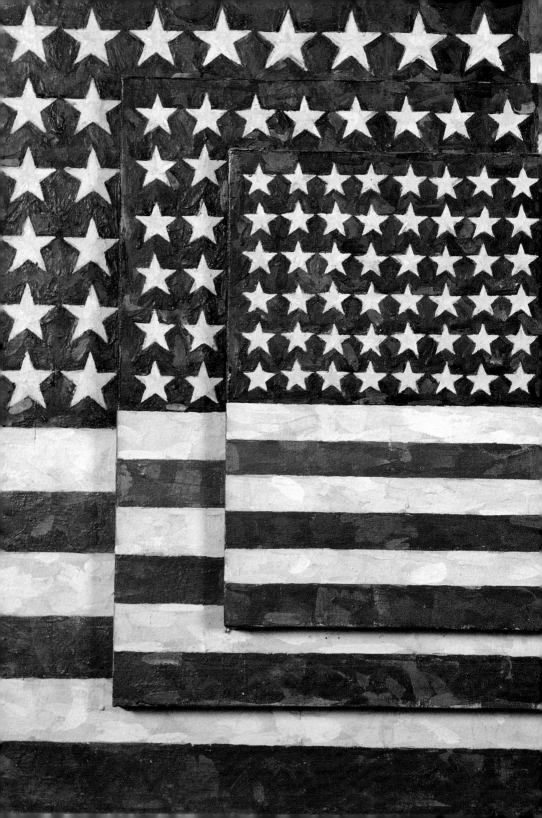

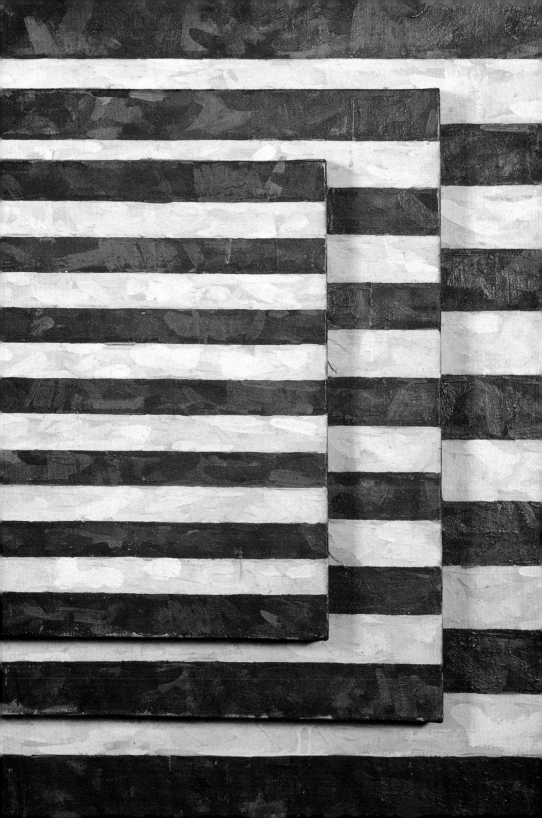

JASPER JOHNS

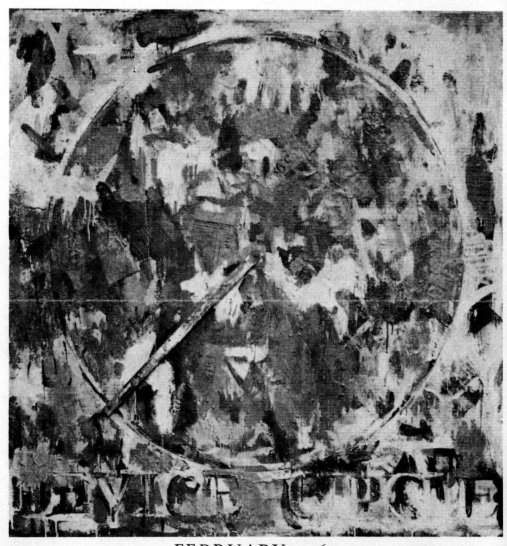

FEBRUARY 1960

LEO CASTELLI

4 EAST 77 ST · NEW YORK

Advertisement for Exhibition, February 1960

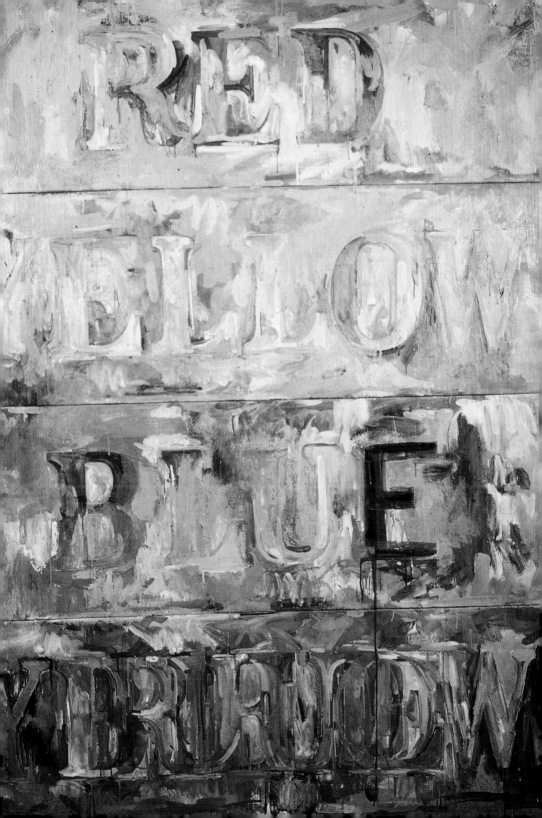

28 28A
FINE GRAIN

29 29A
PANCHROMATIC

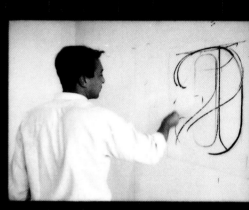

10 10A
FINE GRAIN

11 11A
PANCHROMATIC

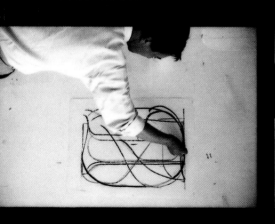

34 34A

35 3 A

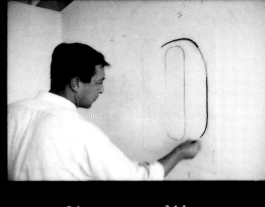

30 30A 31 31A

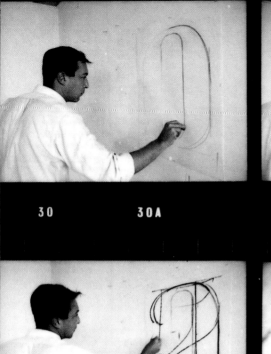

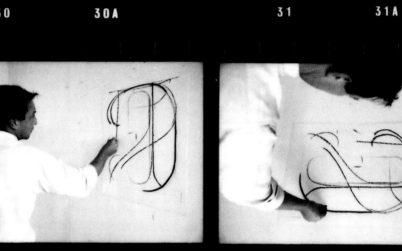

12 12A 13 13A

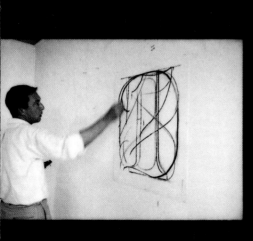

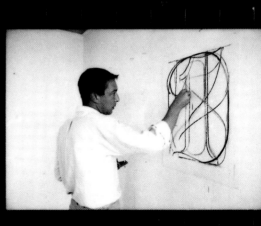

36 36A 37 37A

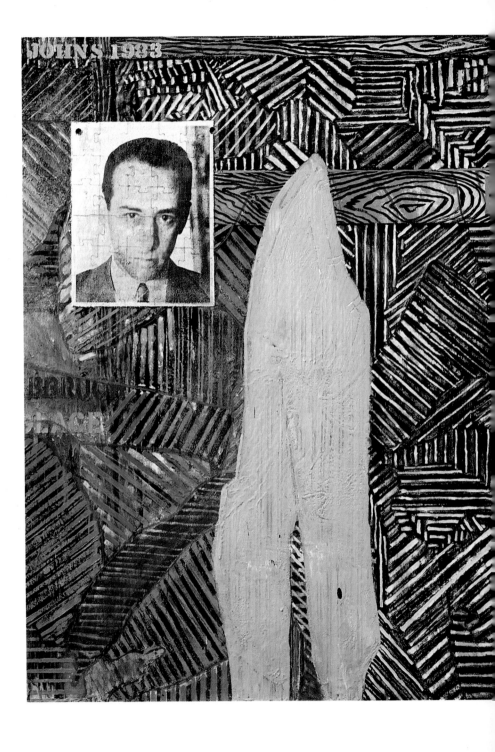

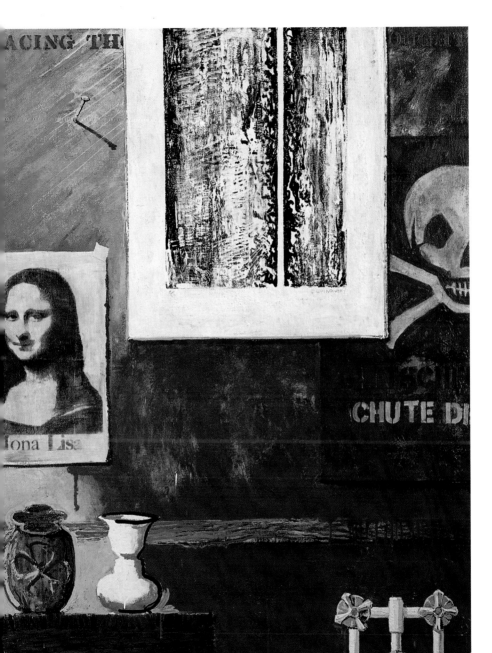

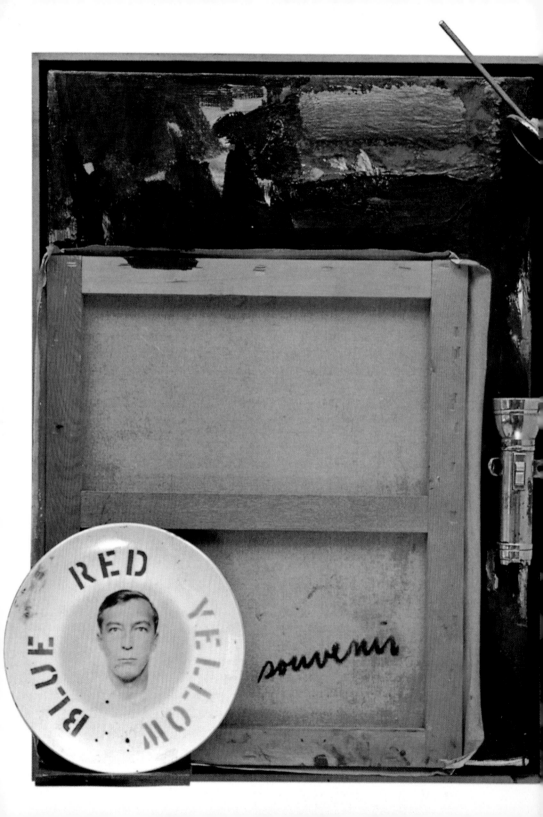

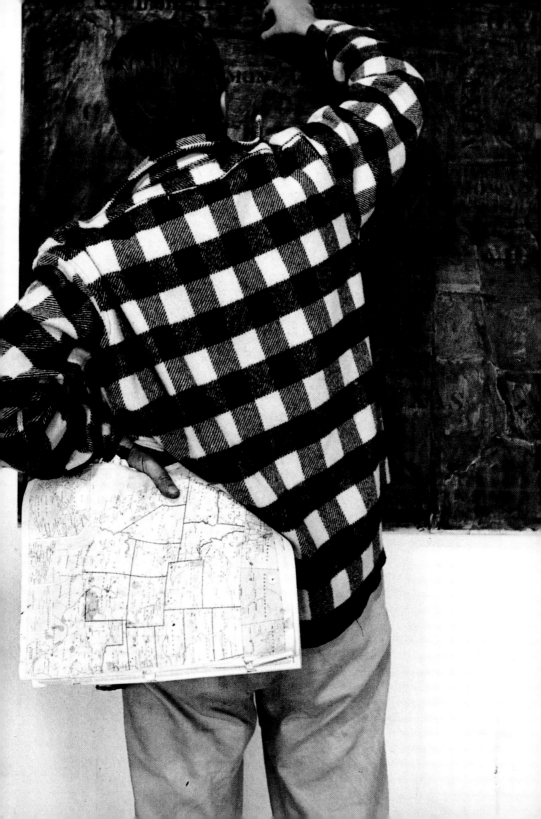

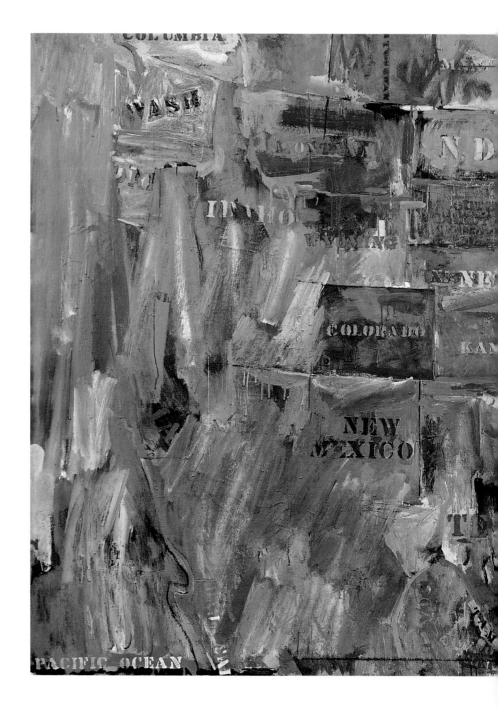

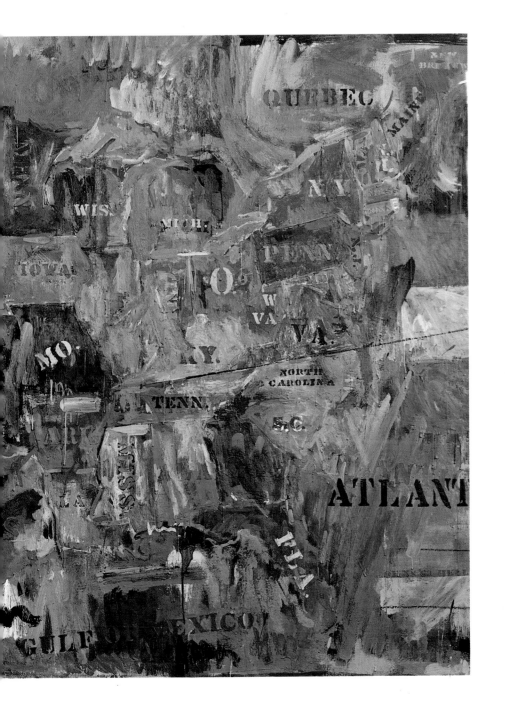

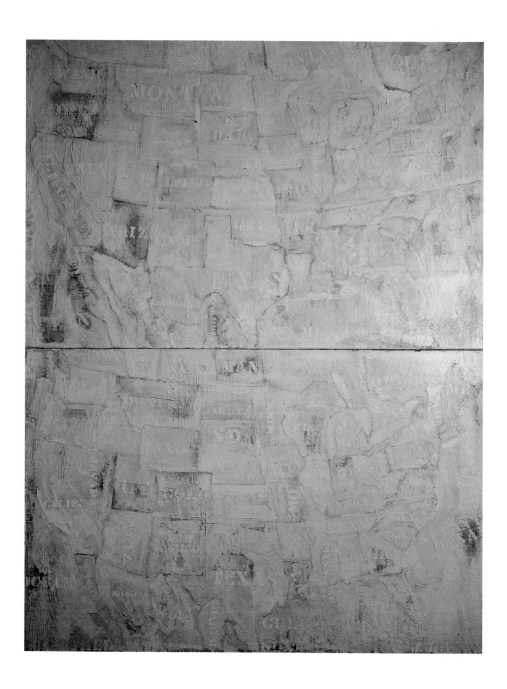

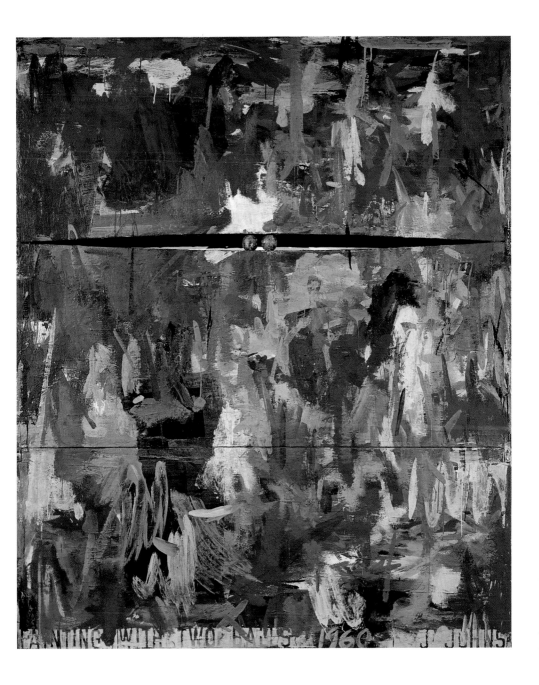

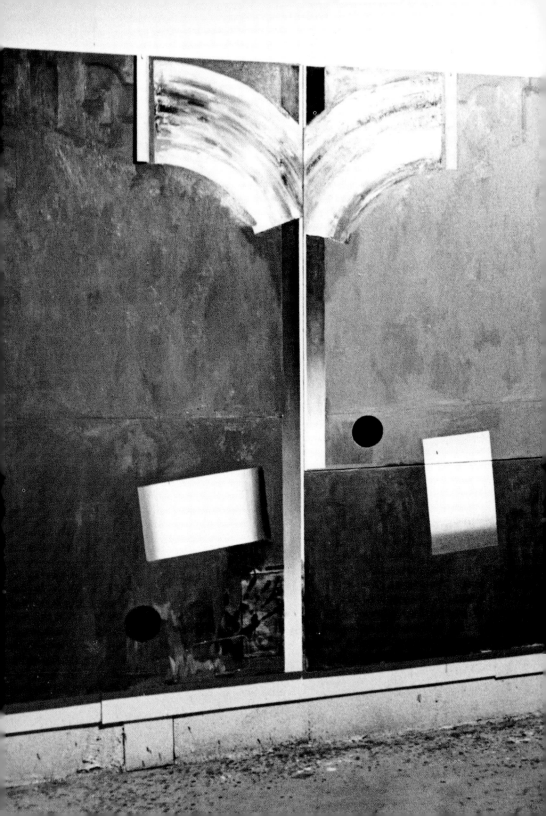

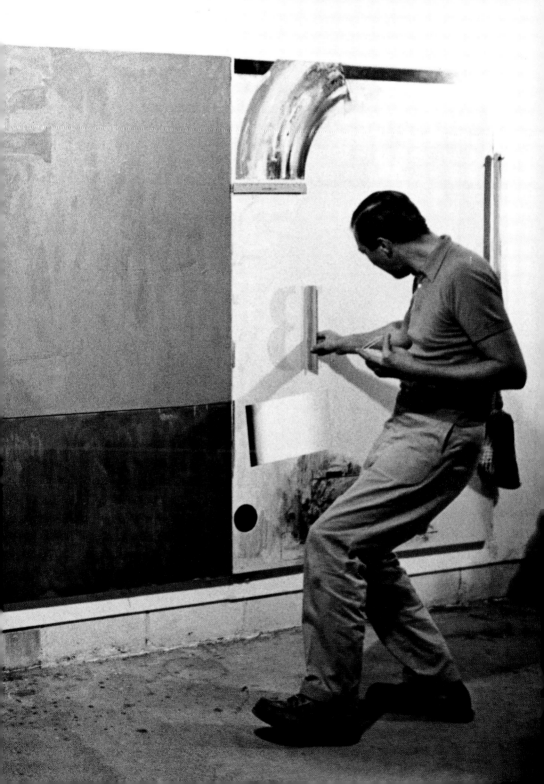

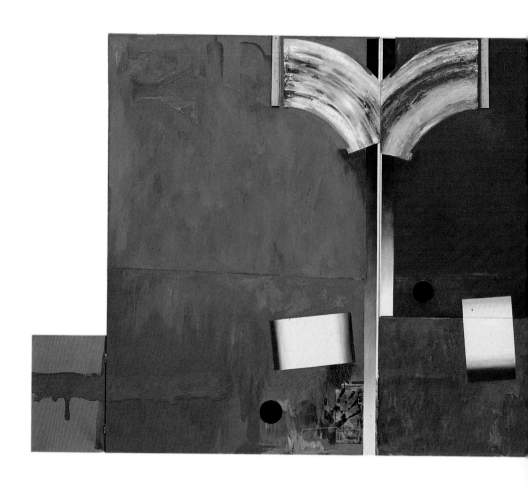

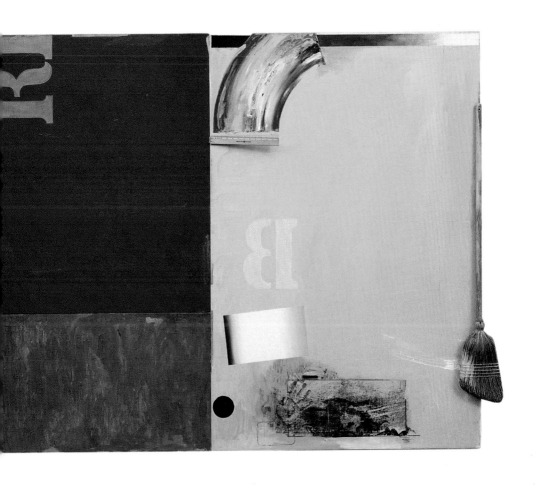

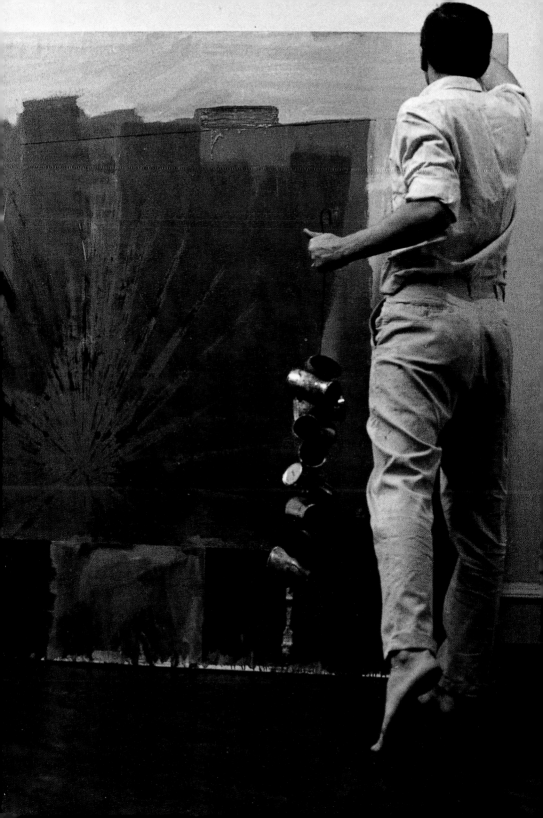

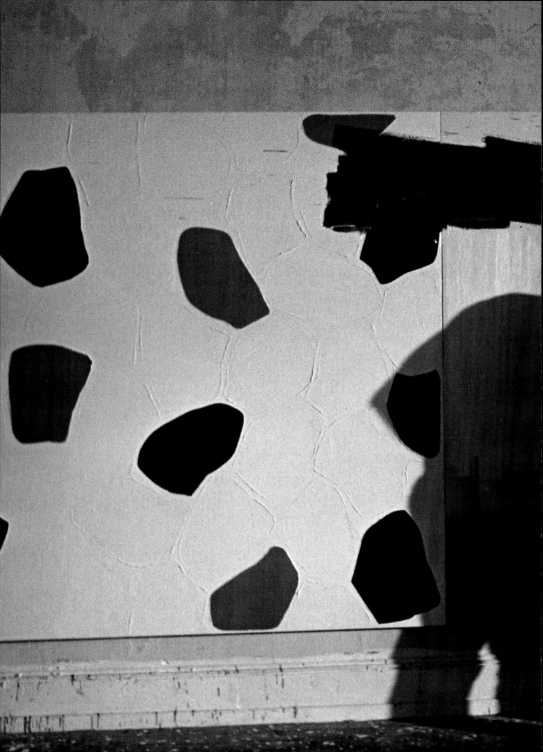

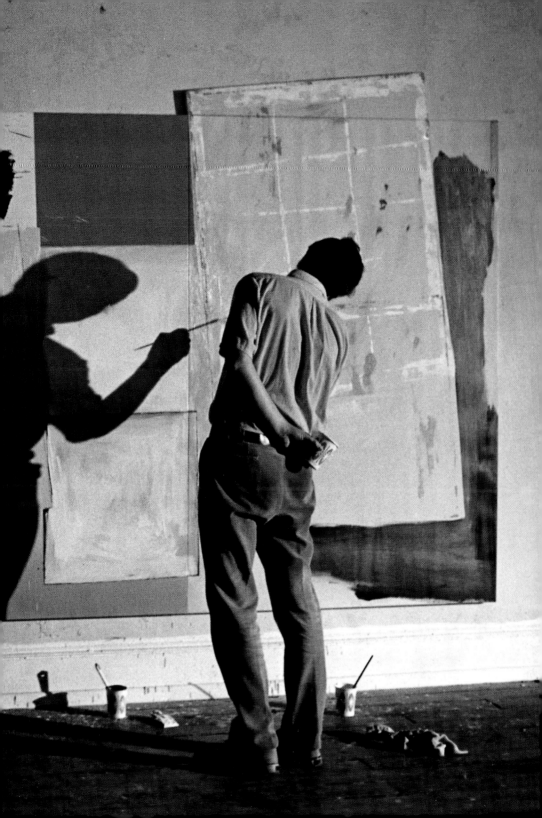

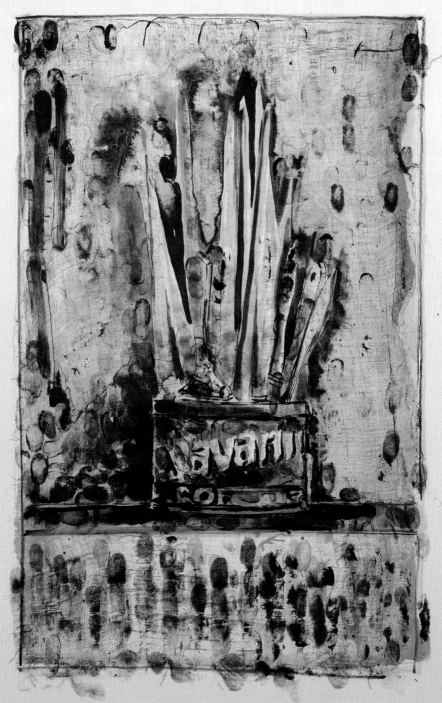

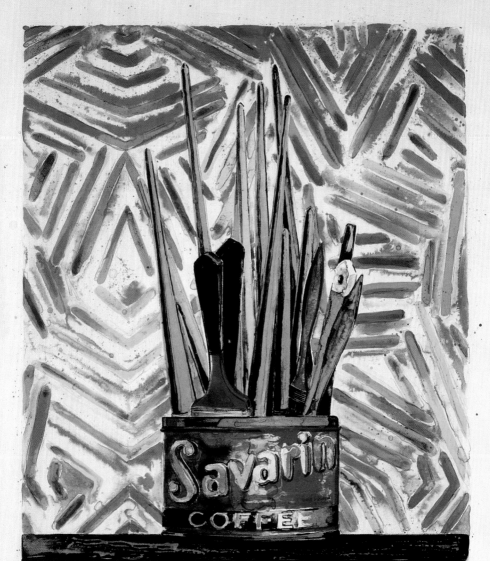

JASPER JOHNS

18 OCTOBER 1977 · 22 JANUARY 1978

WHITNEY MUSEUM
OF AMERICAN ART

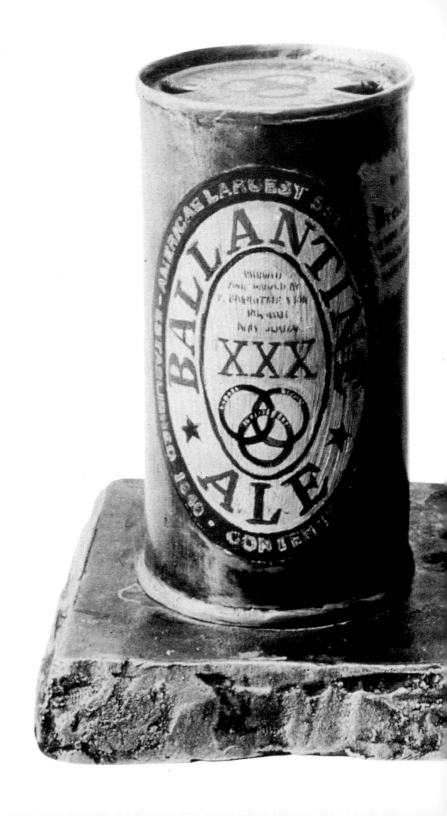

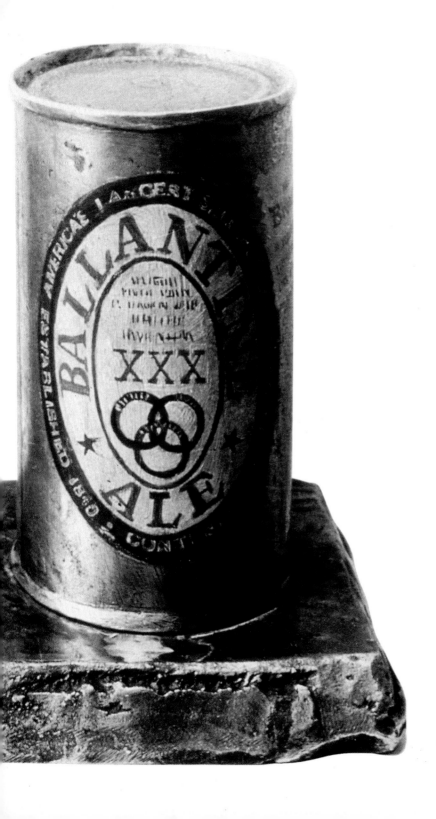

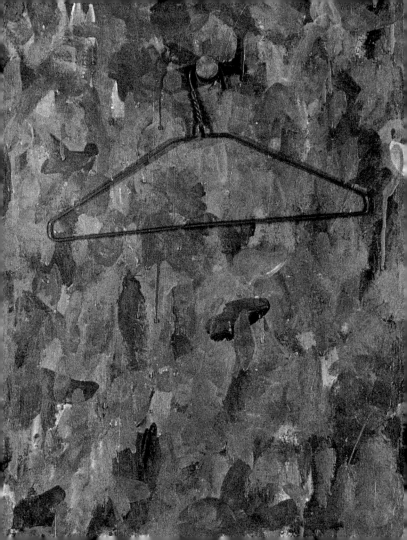

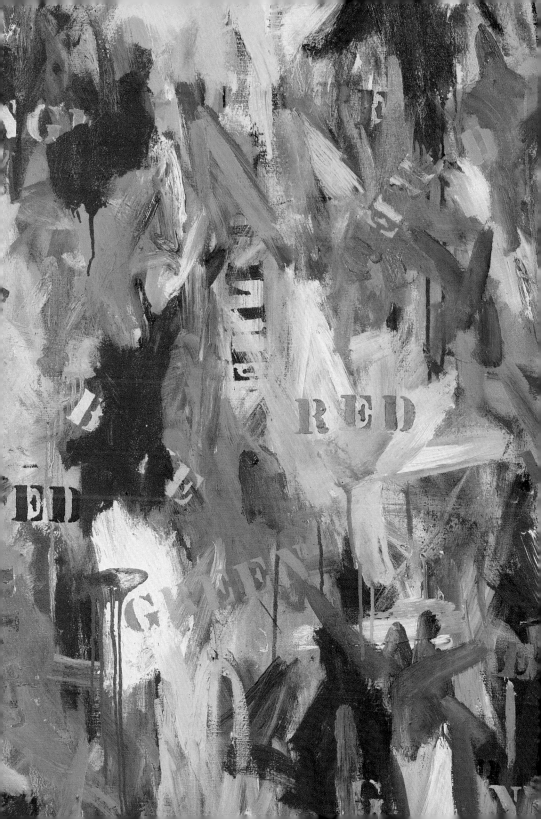

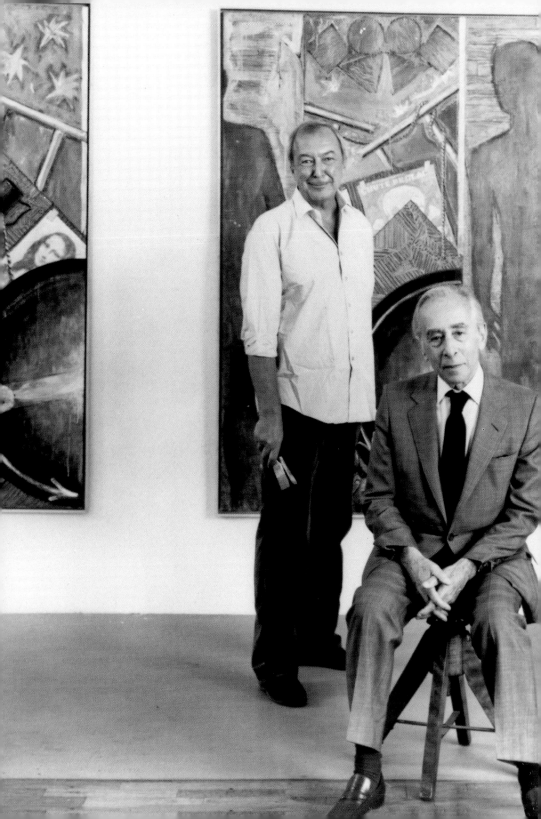

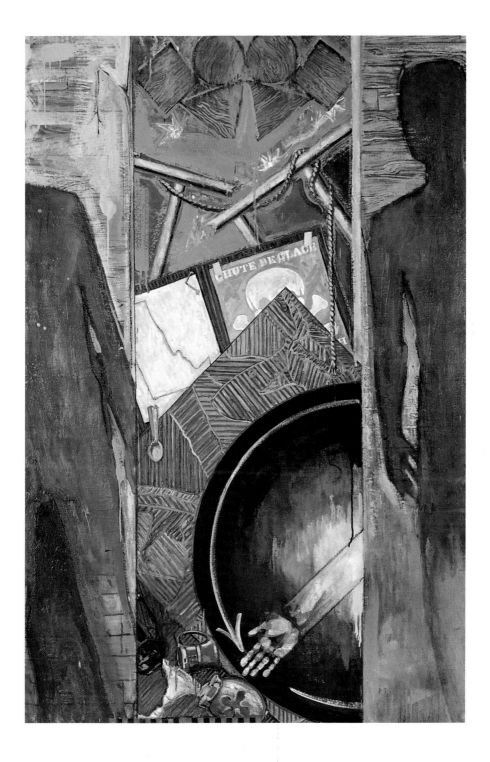

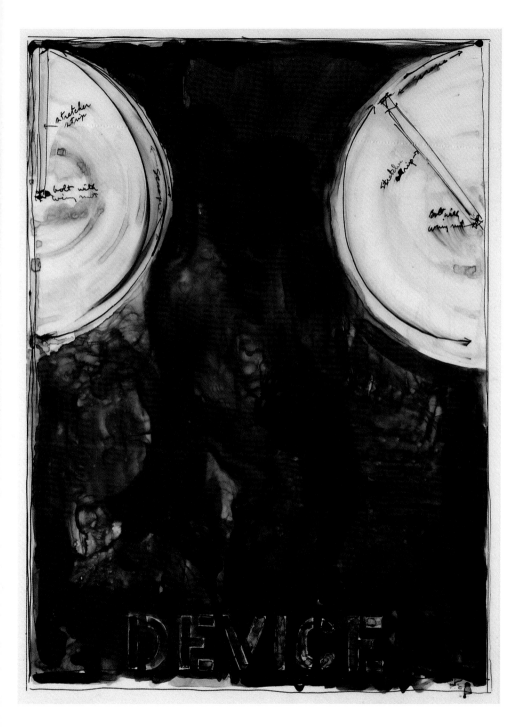

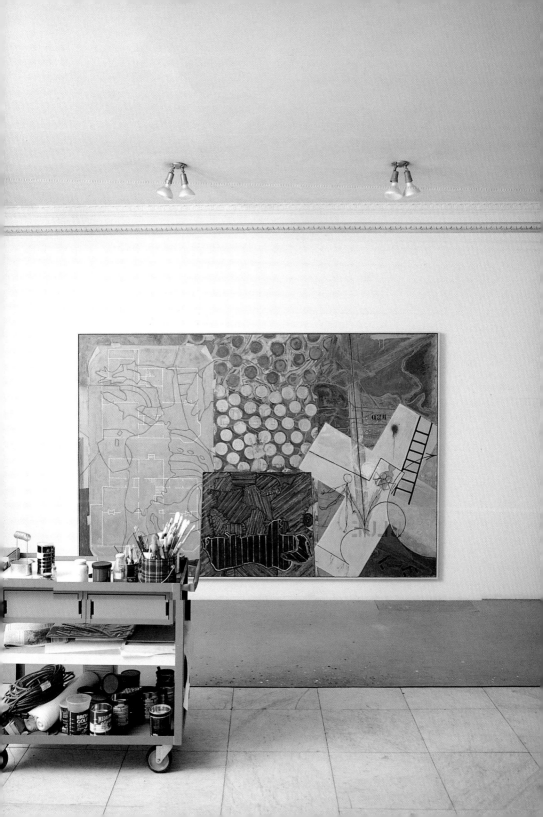

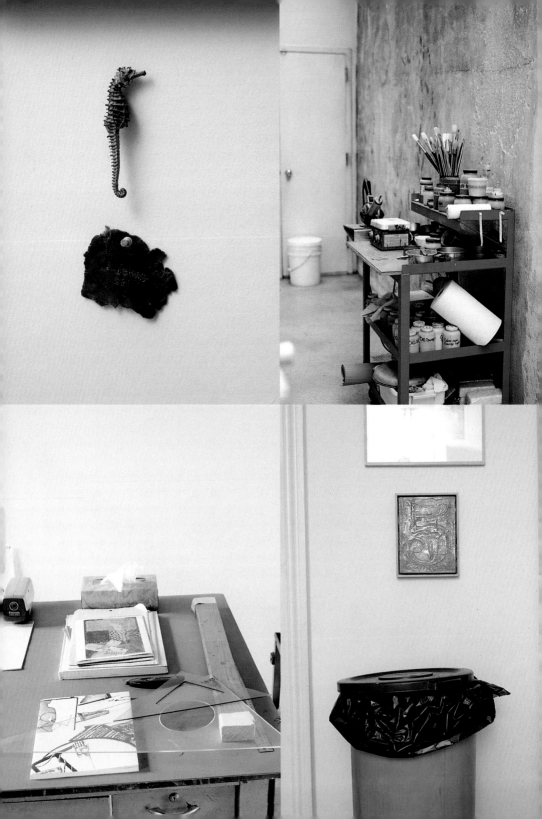

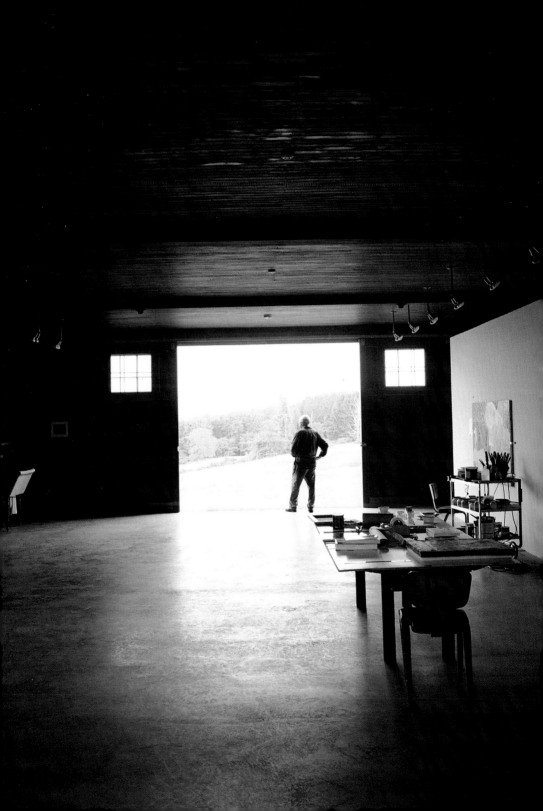

Chronology

1930 Born May 15, Augusta, Georgia.
His parents separate very early; he is educated almost entirely in South Carolina but lives with various members of his family.
Begins to draw by the age of three.

1947 Graduates Edmunds High School with honors. Enters the University of South Carolina, Columbia, and leaves after three semesters.

1948–49 Leaves for New York, where he takes courses at the Parsons School of Design. Discovers Picasso, Jackson Pollock, Isamu Noguchi and Hans Hofmann.

1951 Drafted into the US Army and stationed at Fort Jackson, South Carolina. Discharged in 1953.

1954 Meets John Cage, Rachel Rosenthal and Robert Rauschenberg. Johns works with Rauschenberg designing window displays for Tiffany. Destroys almost all of the canvases he has painted to this point.

1955 Johns paints his first flag and his first target.

1956–57 Begins to incorporate alphabets and objects into his paintings.
Makes first contact with Leo Castelli after a show at the Jewish Museum.

1958 Discovers the works of Duchamp and begins to collect his works.
First show at Leo Castelli gallery.
ARTnews devotes its cover to one of Johns' works.
Alfred Barr, Director of New York's Museum of Modern Art, buys several pieces for the museum.
Johns begins three-dimensional works with *Light Bulb I* and *Flashlight I*.

1959 Introduces the names of colors into selected works.
First solo show consisting of nine paintings at the Galerie Rive Droite in Paris.

1960 Executes painted bronzes in the form of Ballantine Ale and Savarin coffee can with paintbrushes.

1961 Makes first painting of map of the U.S.
Participates with Niki de Saint Phalle, Tinguely and Rauschenberg in performances set to John Cage's *Variation II*.

1962 Discovers Wittgenstein and ultimately reads all of his published works.
Paints *Fool's House*.

1963 Becomes a founding director of the Foundation for Contemporary Performance Arts.

| 1964 | The Jewish Museum and London's Whitechapel Gallery hold a Johns retrospective curated by Alan R. Solomon. |
| | Rauschenberg wins the Grand Prize at the Venice Biennale. |

1964 The Jewish Museum and London's Whitechapel Gallery hold a Johns retrospective curated by Alan R. Solomon.
 Rauschenberg wins the Grand Prize at the Venice Biennale.

1967 Wins prize at IX Bienal Internacional de São Paolo, Brazil.
 Executes the largest painting of his career, *Map* (Based on Buckminster Fuller's *Dymaxion Air Ocean World*), which is later displayed as part of the *American Painting Now* exhibition in the U.S. pavilion at the World's Fair Exposition in Montreal.

1972 "Crosshatchings" appear in large, four-panel composition.

1973 Meets Samuel Beckett, with whom he will collaborate by making thirty-three etchings to accompany Beckett's writings in the 1976 publication *Foirades/Fizzles*. Record price set for a living American artist with Parke Bernet sale of *Double White Map* for $240,000. Designs set and costumes for Merce Cunningham's *Un jour ou deux*.

1976 Last show at Leo Castelli's gallery at 4 East 77th Street, where his work had been shown since 1958.

1977 Major retrospective "Jasper Johns" at New York's Whitney Museum of American Art. Travels to Europe and Japan with the exhibition.

1980 *Three Flags* is sold to the Whitney Museum for $1 million.

1984 "Jasper Johns: Paintings" at the Leo Castelli Gallery (Greene Street).

1985–86 Executes a number of preliminary studies and paints *The Seasons* series: *Autumn, Winter, Spring, Summer*.

1988 Wins the Golden Lion at the Venice Biennale from the exhibition "Jasper Johns: Work since 1974," curated by Mark Rosenthal for the American pavilion.
 Helps organize a show in the Leo Castelli Gallery to benefit the Foundation for Contemporary Performance Arts.

1989 Elected to American Academy of Arts and Letters.

1990 President George Bush presents Johns with the National Medal for the Arts.

1991 Begins a series of paintings incorporating a child's drawing used as an illustration in a Bruno Bettelheim article entitled "Schizophrenic Art: A Case Study," published in 1952.

1996 Retrospective at New York's Museum of Modern Art, New York, traveling to Cologne and Tokyo.

Jasper Johns

Johns and his workshop in Connecticut shortly before his retrospective at the Museum of Modern Art in 1996. Photo David Seidner. © David Seidner.

Figure 0, Figure 1, from *Black Numeral Series*, lithographs, 0.94 x 76.2 m. Museum of Modern Art, New York, John B. Turner Fund, 1968. Published by Gemini G.E.L. © ADAGP, 1997.

Figure 2, Figure 3, from *Black Numeral Series*, lithographs, 0.94 x 76.2 m. Museum of Modern Art, New York, John B. Turner Fund, 1968. Published by Gemini G.E.L. © ADAGP, 1997.

Figure 4, Figure 5, from *Black Numeral Series*, lithographs, 0.94 x 76.2 m. Museum of Modern Art, New York, John B. Turner Fund, 1968. Published by Gemini G.E.L. © ADAGP, 1997.

Figure 6, Figure 7, from *Black Numeral Series*, lithographs, 0.94 x 76.2 m. Museum of Modern Art, New York, John B. Turner Fund, 1968. Published by Gemini G.E.L. © ADAGP, 1997.

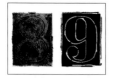

Figure 8, Figure 9, from *Black Numeral Series*, lithographs, 0.94 x 76.2 m. Museum of Modern Art, New York, John B. Turner Fund, 1968. Published by Gemini G.E.L. © ADAGP, 1997.

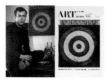

Jasper Johns in his studio in 1955, photographed by Robert Rauschenberg. © Rauschenberg and ADAGP, 1997.
Cover of January 1958 *ARTnews* devoted to Jasper Johns, a few days before the artist's first show in Leo Castelli's gallery. © ARTnews,1958, courtesy of the publisher.

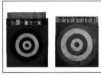

Target with Plaster Casts, 1955, encaustic and collage on canvas with plaster casts, 1.29 x 1.12 m. David Geffen Collection, Los Angeles. © ADAGP, 1997. *Target with Four Faces*, 1955, encaustic on newspaper and cloth over canvas with plaster casts in wood box with hinged front, 85.3 x 66 x 7.6 cm. Museum of Modern Art, New York, gift of Mr. and Mrs. C. Scull. © ADAGP, 1997.

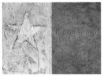

White Flag, 1955, detail, encaustic and collage on canvas in three panels, 1.98 x 3.07 m. Artist's Collection. © ADAGP, 1997.
Green Target, 1955, encaustic on newspaper and cloth over canvas, 1.52 x 1.52 m. Museum of Modern Art, New York, Richard S. Zeisler Fund. © ADAGP, 1997.

White Flag, 1955, encaustic and collage on canvas in three panels, 1.98 x 3.07 m. Artist's Collection. © ADAGP, 1997.

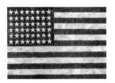

Flag, 1958, encaustic on canvas, 1.05 x 1.54 m. Jean Christophe Castelli Collection, New York. © ADAGP, 1997.

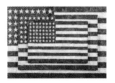

Three Flags, 1958, encaustic on canvas, Whitney Museum of American Art, 0.78 x 1.15 x 0.13 m. Presented as a 50th Anniversary gift, courtesy of The Gilman Foundation, The Lauder Foundation, A. Alfred Taubman, an anonymous donor, and purchase. © ADAGP, 1997.

Poster for Jasper Johns show at Leo Castelli's gallery in February, 1960. *By the Sea*, 1961, encaustic on canvas in four panels, 1.83 x 1.39 m. Private collection. © ADAGP, 1997.

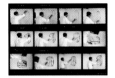

Jasper Johns working on a series of numbers at Edisto Beach. Numbers appeared in his work beginning in 1955 and were reworked in a multitude of compositions, with constantly changing techniques that reflect the artist's unending exploration of the painted surface. Photo Ugo Mulas, 1966. © Ugo Mulas Archives, Turin.

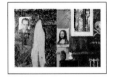

Racing Thoughts, 1983, encaustic and collage on canvas, 1.22 x 1.91 m. Whitney Museum of American Art. © ADAGP, 1997.

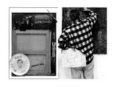
Souvenir 2, 1964, oil and collage on canvas, 0.73 x 53.3 cm.
Collection Sally Ganz, New York. © ADAGP, 1997.
Jasper Johns working on one of his *Map* series. Photo Ugo Mulas.
© Ugo Mulas Archives, Turin.

Map, 1963, encaustic and collage on canvas with objects, 1.52 x
2.36 m. Private collection. © ADAGP, 1997.

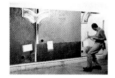
Double White Map, 1965, encaustic and collage on canvas, 2.29 x
1.78 m. © ADAGP, 1997.
Painting with Two Balls, 1960, encaustic and collage on canvas with
objects (three panels), 1.65 x 1.37 m. Artist's Collection. © ADAGP,
1997.

Jasper Johns in his Edisto Beach studio while painting *Unititled*
(1964–1965). © Ugo Mulas Archives, Milan.

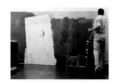
Untitled, 1964–1965, oil on canvas with objects, 1.83 x 4.26 m.
Stedelijk Museum, Amsterdam. © ADAGP, 1997.

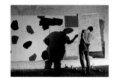
Jasper Johns working on *Studio* (1964), now in the Whitney Museum of
American Art. Photo Ugo Mulas, 1964. © Ugo Mulas Archives, Milan.

The artist in his Canal Street studio working on *Harlem Light* in 1967.
Photo Ugo Mulas. © Ugo Mulas Archives, Milan.

Savarin 3 (Red), 1978, lithograph, 66.2 x 51 cm. Museum of Modern Art, New York, gift of Celeste Bartos. Photo Museum of Modern Art. © Universal Limited Art Editions, West Islip, New York, and ADAGP, 1997.
Poster from the Whitney Museum of American Art's Johns retrospective.

Painted Bronze, 1960, oil on bronze, ensemble: 14 x 20.3 x 12 cm; cans: 12 x 6.8 cm; base: 2 x 20.3 x 12 cm. Ludwig Museum, Cologne, Ludwig Donation. © ADAGP, 1997.

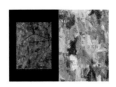

Coat Hanger, 1959, encaustic on canvas with objects, 53.3 x 68.6 cm. Private collection. © ADAGP, 1997.
False Start, 1959, oil on canvas, 1.71 x 1.37 m. David Geffen Collection, Los Angeles. © ADAGP, 1997.

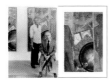

Jasper Johns and Leo Castelli in front of *Summer and Fall*, 1985. Photo Hans Namuth. © Hans Namuth, 1986.
Fall, 1986, encaustic on canvas, 1.90 x 1.27 m. Artist's Collection. © ADAGP, 1997.

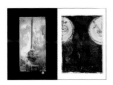

Fool's House, 1962, oil on canvas with objects, 1.83 x 0.91 cm. © ADAGP, 1997.
Device, 1962, ink on nylon film, 53 x 39 cm. © ADAGP, 1997.

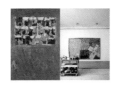

Flag on Orange Field II, 1958, encaustic on canvas, 1.37 x 0.92 m. Private collection. © ADAGP, 1997.
Jasper Johns' studio, photographed by David Seidner in 1996. © David Seidner.

Jasper Johns' studio, photographed by David Seidner in 1996. © David Seidner.

The publisher would like to thank the Leo Castelli Gallery, especially Leo Castelli, Patricia Brundage and Amy Poll, as well as Jasper Johns' studio, especially Jasper Johns and Sarah Taggart.

Thanks also to Antonia Mulas, Camela Mulas, Valentina Mulas, Peter Namuth, Duane Michaels and Bernard Huchet.

Finally, this book would not have been possible without the help of Nicole Chamson (ADAGP), Bob Panzer (VAGA), Mikki Carpenter (Museum of Modern Art), Beppie Feuth (Stedelijk Museum) and Sidney Felsen (Gemini G.E.L.). Many thanks to all of them.